AN INTRODUCTION TO
CALLIGRAPHY

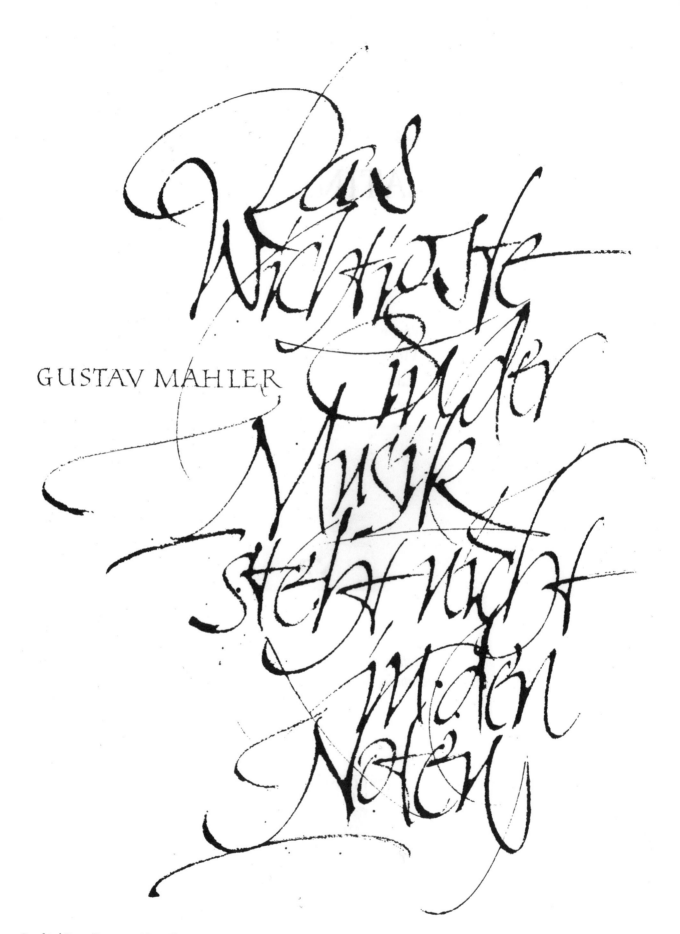

GUSTAV MAHLER

Gottfried Pott, Germany. 30 × 40 cm.

AN INTRODUCTION TO
CALLIGRAPHY

VÉRONIQUE SABARD
VINCENT GENESLAY
LAURENT RÉBÉNA

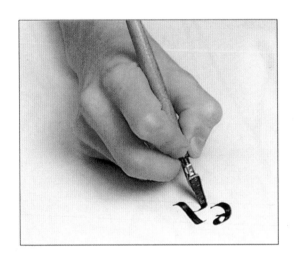

Preface by Roger Druet
Photos by Laurent Geneslay

4880 Lower Valley Road • Atglen, PA 19310

Type set in Trajan Pro/Garamond Premier Pro/Syntax

ISBN: 978-0-7643-5230-0
Printed in China

We would like to thank all those who taught us to love letters, and all those we share this love with. We would also like to thank the calligraphers who joined us to create this book, and also Gérard Blanchard.

Including calligraphy by:

Bernard Arin (France)
Laurence Bedoin-Collard (France)
François Boltana (France)
André Brenk (France)
Michel d'Anastasio (France)
Monica Dengo (Italy)
Michel Derre (France)
Roger Druet (France)
Giovanni di Faccio (Italy)
Vincent Geneslay (France)
Jenny Groat (USA)
Rodolphe Giuglardo (France)
Karlgeorg Hoefer (Germany)
Franck Jalleau (France)
Hermann Kilian (Germany)
Jean Larcher (France)
Guy Mocquet (France)
Laurent Pflughaupt (France)
Gottfried Pott (Germany)
Laurent Rébéna (France)
Anna Ronchi (Italy)
Véronique Sabard (France)
Kitty Sabatier (France)
Hermann Zapf (Germany)

Published by Schiffer Publishing, Ltd.
4880 Lower Valley Road
Atglen, PA 19310
Phone: (610) 593-1777; Fax: (610) 593-2002
E-mail: Info@schifferbooks.com
Web: www.schifferbooks.com

For our complete selection of fine books on this and related subjects, please visit our website at www.schifferbooks.com. You may also write for a free catalog.

Schiffer Publishing's titles are available at special discounts for bulk purchases for sales promotions or premiums. Special editions, including personalized covers, corporate imprints, and excerpts, can be created in large quantities for special needs. For more information, contact the publisher.

We are always looking for people to write books on new and related subjects. If you have an idea for a book, please contact us at proposals@schifferbooks.com.

Other Schiffer Books on Related Subjects:
An Introduction to Arabic Calligraphy, Ghani Alani, ISBN 978-0-7643-5173-0
An Introduction to Chinese Calligraphy, Lucien X. Polastron and Jiaojia Ouyang, ISBN 978-0-7643-5242-3
An Introduction to Japanese Calligraphy, Yuuko Suzuki, ISBN 978-0-7643-5218-8

CONTENTS

Preface

"Breathe your life."

What a magnificent thought from the author Jean Giono, a thought that not only gives meaning to our daily actions, but also expresses the pleasure of writing . . . the joy of being able to express and communicate to a receptive person our friendship, our love, or simply our sympathy, to express our respect to "the other."

There's that fun aspect, like a game, where a blank sheet of paper becomes a place of freedom in the desire for personal expression, even creation. That blank sheet becomes a place where the balance between upstrokes and down-strokes is a source of satisfaction. And it provides a moment where we prepare, following our own feelings, to tap into the right level of meaning—the wonderful moment where the words become a balance between the imagination of images and the imagination of the script. It's the drawing out of our intention and our pleasure.

The liberating graphic drive expresses our thoughts by making time visible, by which we mean the precise instant . . .

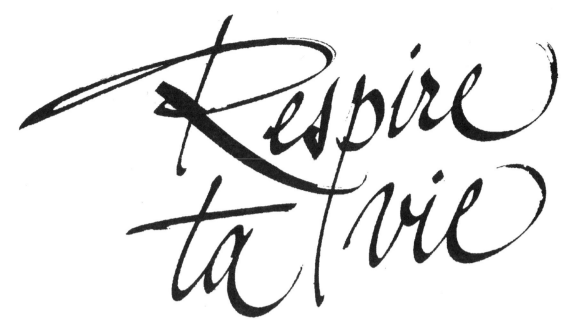

The pleasure in writing expresses respect toward another. The line created is the art of the possible, opening toward a world of tolerance, of swaying to find our center of balance. It is a magical, elusive instant which comes in the moment of correct expression and in meditation. To think about the genesis of a text, is to think about oneself.

Wassily Kandinsky hit the spot when he described this state in which we find ourselves: "Letters act as pure forms and internal melody."

The manner in which we express our words on paper is the expression of our *personality,* of visible *space,* and of our feelings. The musicality of the words and our understanding of them reflect the epoch in which we live. The layout of a text, of a simple letter, the idea of the page space, the production of significant elements, is always the search for an idea of communication with another. Our Western culture is largely based on Greek reflection, Latin humanism, and respect for the human being.

The Western world's graphic, scriptural richness is embedded in a few forms of basic script that have marked out our search for a common identity. These written forms that have been passed down from generation to generation belong to our way of thinking, through the movement of the hand and the entire body. Each stage of these graphic shapes is named: Uncial, Carolingian, Humanistic, Gothic, Bastarda, Chancery, and Cursive. They encourage us in the search for beautiful script—calligraphy.

Practicing this Western art produces balance, reason, and clarity, not only through graphic play, but through the continuation of the flow of blood, of the writing implement, the freeing of our physical and intellectual capacities; through a feeling of enjoyment for the spirit and for the entire body.

You who are going to practice, who understand the meaning of ductus, who are going to live this interior joy, you will be happy. You'll come to understand that writing beautifully with enjoyment is simply the reflection of yourself.

Roger Druet

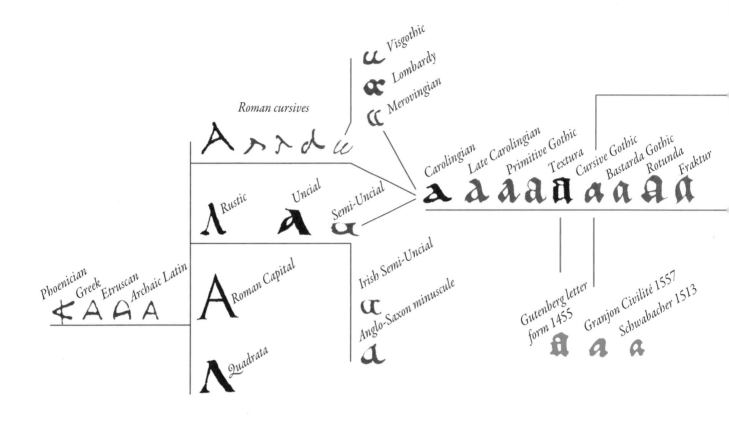

The origins of the Latin alphabet lie in the Phoenician, Greek, and Etruscan alphabets. The first signs appeared in Rome around 600 BCE. During the empire, script took on multiple forms, several forms emanated from the archaic alphabet.

Around the first century BCE we find a classical capital engraved in stone, a narrow capital, Rustic, painted on walls, and a common script called cursive. During the second and third centuries a transformation occurred ending in Uncial and a new common

script. Uncial kept the capital's majestic and calm appearance. In the fifth century, writing was almost nonexistent except in the monastic world and through books. Coming from common scripts, Semi-Uncial gives Irish semi-uncials and Anglo-Saxon minuscules.

THE EVOLUTION OF WESTERN SCRIPT

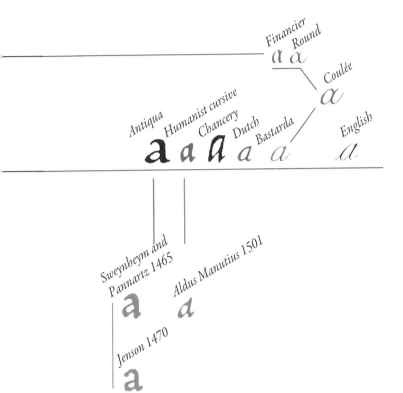

Gothic script was widely used in secular and urban life, including in copyist workshops, universities, and administration centers.

Toward the end of the fourteenth century, Italian humanists discovered Carolingian manuscripts and put together a script very close to it: Antiqua. This new form spread throughout Europe thanks to books. Parallel with this, a cursive version appeared; both inclining and ligatured, it eventually became Chancery script, of which we will later see beautiful engraved examples. During the seventeenth century in France, it became Bastarda script with its rounder forms. Simultaneously Rotunda script was used, created from Gothic cursive and Coulée. In the eighteenth century, the English created a regular, legible script modeled on Italian Bastarda: English script. Our script has changed very little since.

Other, local interpretations developed: Merovingian, Laon, Luxeuil, Visgothic, and Beneventan scripts. They are very ligatured, and not very legible. The revival of the Carolingian dynasty saw the appearance of a new script: Carolingian. Elaborated in different monasteries (such as Corbie and Beauvais) in the eighth century, it found its definitive form in Saint-Martin-de-Tours, and was then distributed throughout the empire and across Europe.

During the twelfth century, Carolingian became narrower, straighter, its curves breaking, and it eventually became Gothic script.

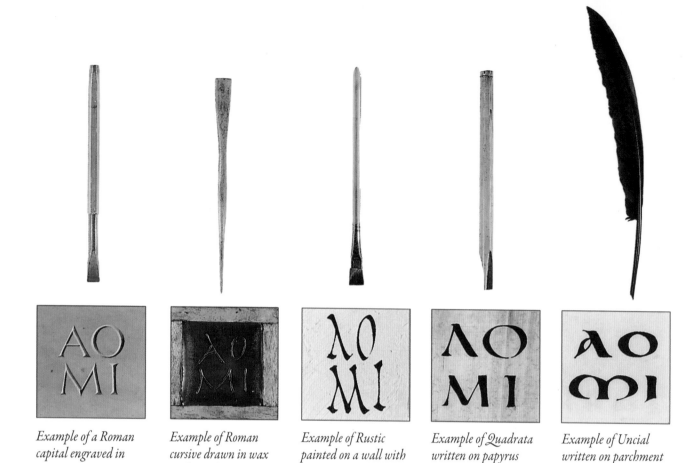

Example of a Roman capital engraved in stone with a graver.

Example of Roman cursive drawn in wax with a stylus.

Example of Rustic painted on a wall with a brush.

Example of Quadrata written on papyrus with a reed pen.

Example of Uncial written on parchment with a feather quill.

In the age of computers, multimedia, and satellites, writing might first appear to be a vestige of the past. A communication tool, it's a system that allows transcribing evasive words more or less durably. From what moment can we speak of writing existing? "First one needs a group of signs that have a meaning pre-established by a social community for their use . . . then these signs have to allow the recording and reproduction of a spoken phrase," says James Février in *The History of Writing.*

From one region to another, one continent to another, script has taken on thousands of forms under the influence of people and their languages, of societies whose needs vary, and in consequence entire geographic, climatic, and biological (animal and vegetable) factors. If stone, papyrus, or parchment hadn't existed in the Mediterranean Basin, would our script resemble cuneiform script drawn in clay, or ideograms stitched into the weave of cloth? Writing reflects the civilizations and cultures it comes from.

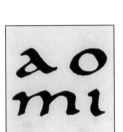

Example of Carolingian written on parchment with a feather quill.

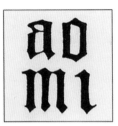

Example of Gothic Textura written on parchment with a feather quill.

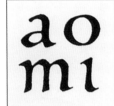

Example of Antiqua written on parchment with a feather quill.

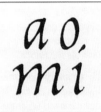

Example of Chancery written on paper with a feather quill.

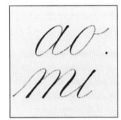

Example of English written on paper with a metal dip pen.

We can divide script into three categories: institutional script, an expression of power; book-based script, an expression of knowledge; and epistolary script, an expression of current affairs. The monumental form of the Roman capital is linked to a support of stone, to the techniques of engraving, and to its institutional function. In the same way, the flexibility and amplitude of cursive script are the direct consequences of the malleable wax in which it was drawn with a stiff, pointed instrument that has no upstrokes or downstrokes; it was used to take down rapid notes.

Another example: the use of parchment and a feather quill which, after the papyrus and reed pen, allows for a greater precision in the writing's lines. The Carolingian lowercase letter wouldn't have its particular quality without these technical parameters. Finally, English script appeared thanks to the use of the pointed quill (this script isn't compatible with a larger tool), and its diffusion throughout Europe was assured by the great economic power enjoyed by England. These examples illustrate the close relationships between script, its function, and its layout.

Today the largest part of written communication comes from typography, whether in books, newspapers, all sorts of printed documents, pixels on the screen . . . but we should remember that the first signs of the Roman capital appeared around 600 BCE, while typography started to gain a foothold in the West with Gutenberg in around 1455. If calligraphy is the trace of an instantaneous, mastered gesture, typography is a mechanical reproduction of letters that were drawn first. Which basically means that typography comes from calligraphy.

11

1. Rexel Cumberland (Great Britain) pencil with a large lead. Using the flat of the lead is equal to the bevel on an ink pen.

2. Conté chalk, same use as above.

3. Flat Japanese brush, extra-fine symmetric hairs, Plexiglas handle (4 sizes).

4. Blown glass inkwell, two compartments.

5. Kuretake (Japan) beveled marker, double head (5 / 2 mm), extra-hard, and pigment ink.

6. Reed pens. Two types: on the left, oblique, for Arabic calligraphy; on the right, for Western script.

7. Spun-glass dip pen with frosted glass handle (Switzerland).

8. Automatic pen (Great Britain): nickel-silver nibs with white wooden handle, 13 sizes. The large model gives better contrast between up-strokes and downstrokes.

9. Coit pen (USA): copper pens with a reservoir mounted on a plastic handle. Twenty models.

10. Marbled lever fill pen nib holder (Germany).

11. Oblique pen nib holder for English script (USA).

12. Pen nib holder with grained cork end (Germany).

13. Sponge brush mounted on a wooden handle, four widths (France).

14. Kuretake (Japan) brush pen with India ink cartridges.

15. Calligraphy pen for beginners, solid steel nibs in five widths (Japan).

16. Osmiroïd (Great Britain) calligraphy pen with 26 interchangeable nibs, including a rare copperplate nib.

17. Comptoir des Ecritures (France) calligraphy pen. Pen nib holder in steel, three sizes. This pen is for everyday writing as well as being a specialist's tool.

18. Yanliao (China) extra-fine watercolors, vegetable and mineral pigments, sized with deer musk.

19. Regular and clipped (left) goose quills (Switzerland).

20. Winsor & Newton (Great Britain) watercolors in pots.

21. Talen (Holland) gouache.

22. Chinese professional-quality ink stick, #10, made of soot from candlenuts. In China it is a professional quality.

23. Swiss ink based on ancient recipes and vegetable pigments.

24. Platignum (Great Britain) ink.

25. Rohrer & Klingner (Germany) synthetic India ink, fifteen colors.

26. Traditional English ink, 24 shades (France).

27. Pébéo (France) synthetic India ink.

28. Dr. Martin's (Great Britain) complete cleaner for ink-encrusted pens.

29. Chinese liquid ink, a mix of chimney soot and animal glue.

30. Scottish travelling inkwell in polished pewter. Comptoir des Ecritures (France).

31. Pheasant quill for fine drawing and writing.

32. Accordion writing pad made of xuan rice paper for brush script (China).

33. Lokta paper, made from mulberry fibers (Nepal).

34. Papyrus, ideal for reed pens and India ink (Egypt).

35. Paper book with a silk damask cover; the paper is excellent for pen work (China).

36. Xuan rice paper book (China).

37. Block of A4 imitation papyrus, perfect for pen work (Great Britain).

38. Book of mulberry paper (Nepal).

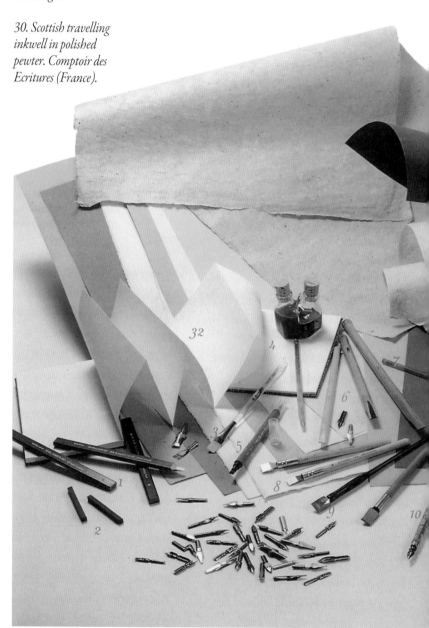

MATERIALS

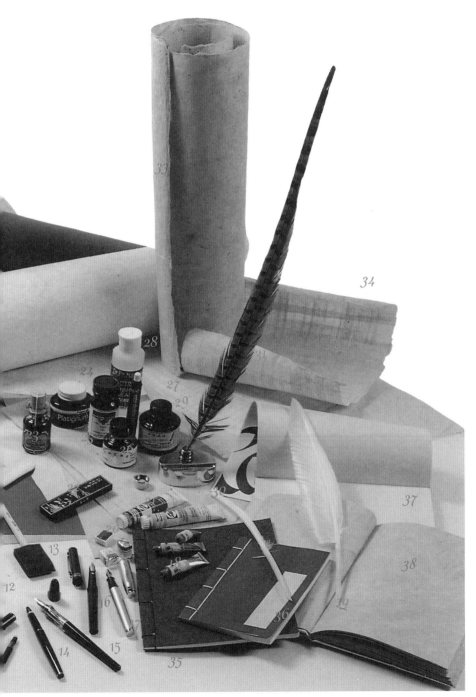

Why learn calligraphy? Making a mark, leaving one's imprint, is the beginning of written communication, but it is also a pleasure that everyone knows. Calligraphy is an artistic discipline, based on observation, the awareness of the relationship between the eye and the hand, the analyzing of gestures through the sign written on the paper.

Through calligraphy, you will discover the pleasure of repeating these signs, of finding more beautiful forms, of searching for a rhythm, for varying cadences.

For this, you need to learn a few useful principles that will help you progress. You might find it all seems a bit strict at first, but these are the structures that will help you to go further and to eventually personalize the styles you've learned.

1. Poster Pen by Leonardt (Great Britain). Six sizes from 4 to 15 mm.

2. Poster Pen by William Mitchell (Great Britain). Eight sizes from 3 to 10 mm.

3. Copperplate by William Mitchell (Great Britain). Special model for very slanted English script.

4. Stenofeder by Brause (Germany).

5. Citofeder by Brause (Germany). Gilded nib for cursive script.

6. Music Pen #69 by Leonardt (Great Britain) in matte blue steel with the central part folded under the nib to make a reservoir. With a double-split tip, this pen was originally intended for creating elegant hooks.

7. Crown Pen #41 by Leonardt (Great Britain). Classic pen for English script.

8. Ball Point Pen by Leonardt (Great Britain). Classic pen for script.

9. Italic Pen by William Mitchell (Great Britain). Five right sizes and five left oblique sizes.

10. Bandzug by Brause (Germany). Nine sizes from 0.5 to 5 mm. Very useful, with acute beveled angles.

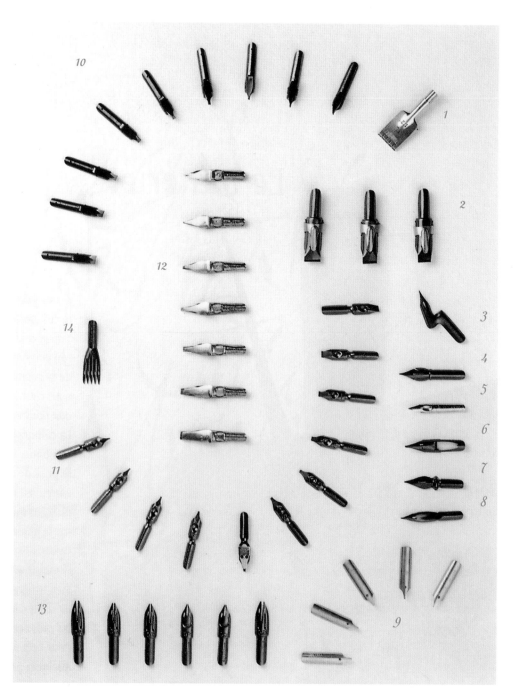

11. Round Hand by William Mitchell (Great Britain). Six widths for the right and ten left oblique sizes from 0.5 to 5 mm. This pen comes with either a natural reservoir or a removable one.

12. Speedball "C" by Hunt (USA). Seven right sizes from C0 to C6, and five left oblique sizes. With its flexibility and large reservoir, it is an indispensible pen.

13. Scroll Pen by William Mitchell (Great Britain). Comes in two models: identical double lines or two unequal lines, each in three different sizes.

14. Five-Line Pen by William Mitchell (Great Britain). Five tips, two of which are split. Originally intended for drawing musical staves, this pen offers a multitude of possibilities.

Basic materials

To start off well, you should use good quality materials. The previous pages show just a few of the many examples available. The basic materials are a pen nib holder and a wide-tipped nib (or pointed, for English script), and a medium (ink, gouache, or watercolor diluted in water). Most of the nibs adapt to all types of pen nib holders. Of course, you can try various tools and experiment with possibilities. As well as material for calligraphy, add a ruler, a #2 pencil, an eraser, a utility knife or a pair of scissors, a square, a paintbrush, Scotch tape, and a piece of cloth or blotting paper.

Paper

Use ordinary white paper. Make sure that the surface isn't glossy or coated, which won't absorb ink at all. On the other hand, if it's not too absorbent your ink will bleed.

In art supply stores you will find a vast range of different types of paper. Textured paper, such as *Ingres d'Arches* by Fabriano Roma or many watercolor papers, generally gives an uneven line that shows the paper's surface. They can be interesting for working on large sizes of calligraphy, but are not good for fine, precise work; instead choose smoother paper, such as C-grain (Canson), Popset, or Johannot, which are particularly adapted for English script.

Medium

Your choice of medium is important; it impacts your work very distinctly. For example, gouache has a matte, opaque look, while watercolors give transparent-type effects and offer a large variety of tones.

The best approach is to make a collection of samples. Take your papers, tools, and mediums and test them with each other. Whether the results are good or bad, keep your samples as a reference to help you make your choices. There's nothing like experience!

Body position

Look at the above diagram. It shows the correct body position: straight back, both feet flat on the floor, with the elbows able to move freely over the table. It also shows where the lighting source should be in relation to your hand to avoid awkward shadows, as well as the position of the work surface.

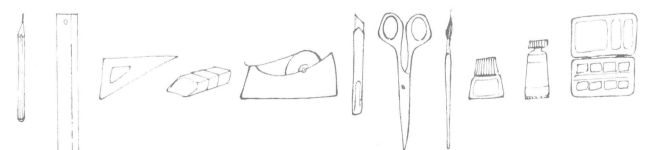

15

Preparing the pen

Before using a pen, run it over an open flame or under hot water to remove the thin film of protecting grease.

Filling the nib

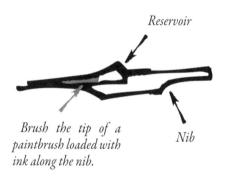

Brush the tip of a paintbrush loaded with ink along the nib.

Reservoir

Nib

Instead of dipping the nib directly into the inkwell, it's better to fill it with a brush to avoid the first line being too thick.

Each time you finish using it, clean the nib in warm water, scrubbing it if necessary.

Dry it completely to avoid rusting.

Checking the nib

For nibs with independent reservoirs, check that the fasteners aren't too tight or too close to the tip. The ink should be in the reservoir and not under or on the nib. When drawing a line, make sure that the tip of the nib is entirely touching the paper.

The guideline and the x-height

The height of the letter is determined by the width of the nib. The two horizontal guidelines marking the letters' height are therefore drawn following that measurement:

With a ruler and a pencil, draw a line, and then place the pen flat, the nib vertical without any angle or pressure, and draw a square.

Mark the appropriate number of nib strokes and draw another line parallel to the first, using a T-square. You have just determined the x-height of the letter. You will do your calligraphy between these lines. X-height corresponds to the body of a letter that has neither ascender nor descender. The x-height plus ascenders and/or descenders is called the body height.

Angle of the nib

Generally, the angle of the nib should remain the same from the beginning of a letter to the end, no matter what movement is being done (curve, horizontal, vertical, oblique . . .), to get a good distribution of ink and good positioning of the downstrokes and upstrokes.

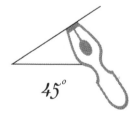

45°

Your first lines with the pen

Upstroke and downstroke

To get a good feel for the motion of upstrokes and downstrokes, draw your horizontal guidelines. Then take your pen and hold it at a 45° angle; draw a straight vertical line. When you reach the baseline, slide the pen upward at the same angle, in an upstroke as in the example above.

Modulating the line

One of the biggest advantages of working with a pen lies in the possibility of modulating the line. When you put pressure on the nib, it spreads. This particularity allows you to vary the thickness of the ascender. Instead of having a uniformly straight vertical line, work on the nib!

Start on an attack line with a starting pressure, lighten the pressure in the optical center of the ascender, and finish the line by reapplying the pressure to give a firm finish. Applying and lightening the pressure should be done progressively: the result will be more harmonious and elegant.

Overshooting the x-line

Certain parts of a letter should slightly overshoot the x-line so that all the letters appear to be the same size. The horizontals are aligned on the line while the points and curves overshoot it:

The optical center

The optical center is situated a little above the geometric center; it's marked in red in the diagram. You should take this into account to equalize the letters, notably when placing the bar in letters like E, F, or H.

You will also notice that the bar of A or G is slightly below the geometric center. In general, you should avoid dividing a letter into two equal parts.

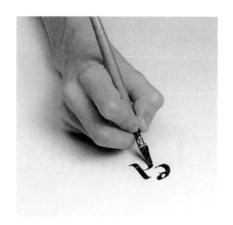

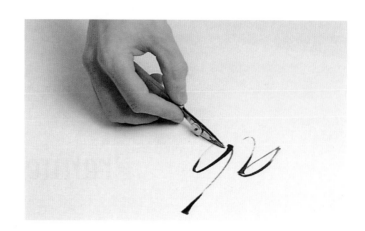

The intraspaces

The intraspace is the space between the letters. When we draw letters to write a word or phrase, we should position the letters in a way that the space between them appears "identical." To achieve this, you should leave more white space (distance) between two straight lines than between two curves.

Look at the diagram below. The geometric shapes represent letters; for example, the circle could represent O or C, the triangle could represent A or V, and so on. The spaces (straight/curve, straight/oblique . . .) are regulated based on the first intraspace, between the two straight lines.

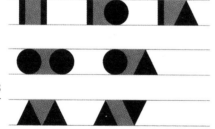

Vertical alignment

The below diagram highlights the adjustments you should make to give the impression that letters with different structures appear to be vertically aligned.

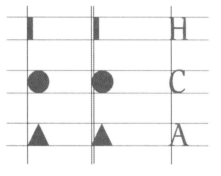

Counters

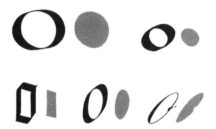

When you are drawing your letters, visualize the counter—the space inside the letter—instead of the line. For an Uncial O to be perfectly round, the white interior area should seem round, even though the line itself is slightly oval. It isn't the wrapping that makes the gift, but the gift inside! Above is a comparison of the "O" in the five scripts covered in this book, with their counters shown beside them (Uncial, Carolingian, Textura, Chancery, and English scripts).

Each tool requires a particular way of holding it and a particular position. A dip pen is held like a ballpoint pen. A drawing pen isn't a specific tool for calligraphy. Use it for "gestural" work.

Large-scale calligraphy is done with a large sized tool (here, a piece of carved wood); it is easier to work standing rather than sitting down because this gives you room for free movement.

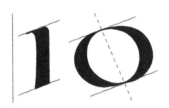

Uncial: nib angle 20°, round letter axis is oblique, straight letter axis is vertical.

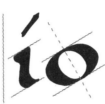

Carolingian: nib angle 30°, round letter axis is oblique, straight letter axis is vertical.

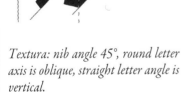

Textura: nib angle 45°, round letter axis is oblique, straight letter angle is vertical.

Chancery: nib angle 45°, round letter axis is oblique, straight letter axis is at 9°. Chancery: nib angle 45°, round letter axis is oblique, straight letter axis is at 9°.

The forms

For each type of script, we use two determinant letters as a reference: the *i* and the *o*. You can structure your work based on these two letters. The *i* gives you all the straight letters and the *o* all the curved ones. The width of the *o* will determine the width of the N and then all the other letters. But look carefully at all the determining factors pointed out here: the nib angle, the axis of the round and straight letters, the "color" of the letters (relationships between black/white, downstroke/upstroke).

English: axis of both round and straight letters is at 55°.

A few beginning exercises

Each time you approach a new script, go back over the main points of this basic exercise, paying careful attention to the body height and the corresponding angle of the nib. To get the most out of this exercise, carefully follow the ductus in each line.

First line: Do a few lines of alternating verticals and horizontals.

Second line: A circle is composed of two semicircles connecting in the upstroke. When you draw the entire circle, or simply an O, you should anticipate the space the first curve takes in relation to the preceding letters. For the second curved line line, visualize the junction between the two half circles; for this, once you have finished the first part of the circle, lift your arm and trace the reverse half in the air. This will give you continuity in the movement and will preserve

the memory of the first line, to join the two half circles in their upstroke. To start off, you can practice just one portion of the circle, as shown in the example line below.

Third line: From curves, move on to verticals, following the example on the third line below. You'll find this sequencing in N and M in particular.

Finish the line with a sequence of diagonals.

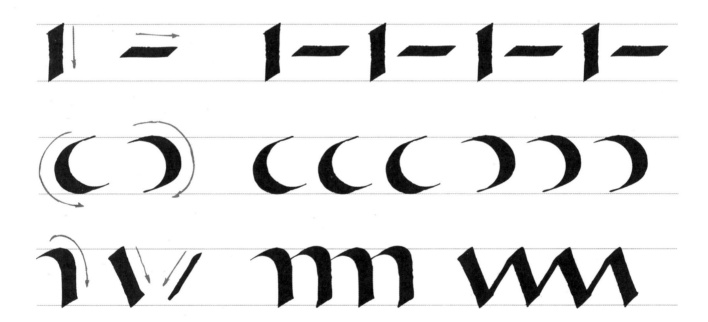

Before starting to study the alphabet, loosen up you wrist and your hand. Use a regular 8½" × 11" sheet of paper and a basic pen. A Speedball was used in the example below. Coordinate your thoughts, and your movements will result in balance between the letters, in equilibrium between the strokes and the empty spaces.

The exercises on this page are by Roger Druet.

▼

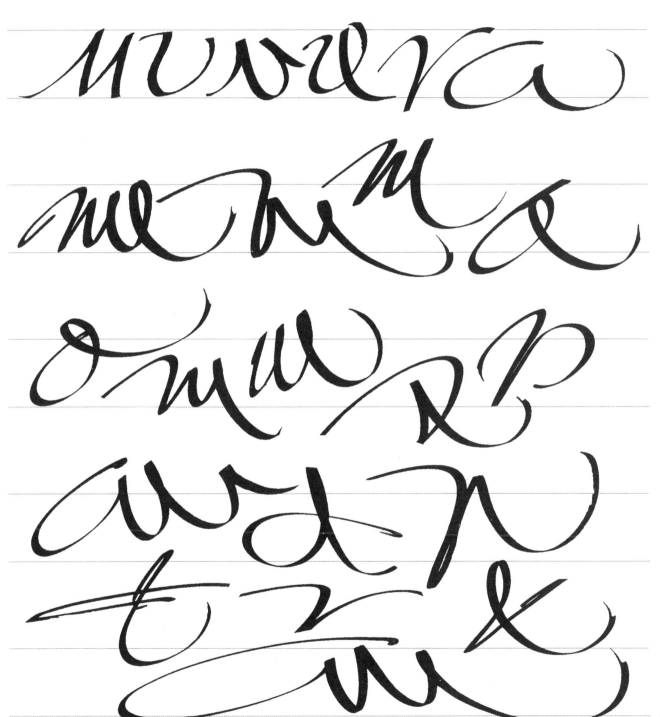

Byzantine art.

UNCIAL

Inspired by the Roman capital and Cursive script, the first Uncial characters took form during the third century CE. Like Cursive script, this large, rounded script has short ascenders and descenders for the letters D, F, G, H, L and Q. Interestingly, Uncial was often composed in the space between words. The script used by the first Christians and then of the monks, it had its hour of fame during the fifth century, essentially for ecclesiastical texts. It was used until the ninth and tenth centuries. It is found in works from Carolingian times (750 to 987) as titles and the first lines of chapters.

Uncial: About the script

Uncial is divided into three periods.

Roman Uncial (from around the fourth to the sixth century)

ISTISETEXEMPLU
TERISDILECTIONI
CISUESTRONINE

Classic Uncial (from around the sixth to the seventh century).

CIÉSETSIQUALO
OPTINERINAMA
ABARCENDISOS

Late Uncial (from around the seventh to the ninth century).

IHSCOCITATIONESE
RUMRESPONDEN
DIXITADILLOS

Toward the eleventh and twelfth centuries, a form of letter derived from Uncial appeared that was used as a dropcap with Gothic script.

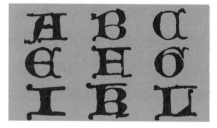

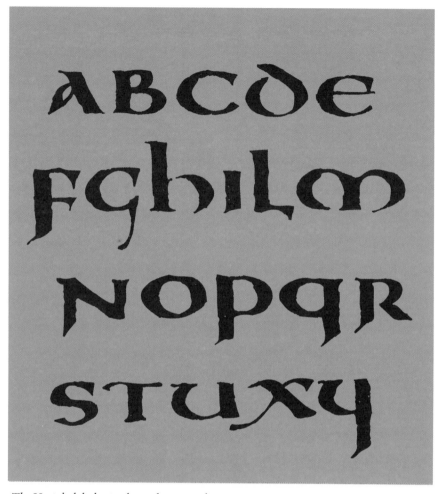

The Uncial alphabet in the sixth to seventh century.

Uncial is a script with a majestic, even slightly pompous appearance. The letters are very calm, drawn without "flightiness," with a large structure (especially with classic Uncial).

Uncial is based on circles and squares, and all its characteristics (majesty, fullness, roundness) call to mind quite clearly Byzantine art and architecture. Note that in Uncial, there is no "capital" or "lowercase." To mark the beginning of a word, a paragraph, or a sentence, we use a dropcap—a letter in a different color or of a different size.

Uncial: Characteristics

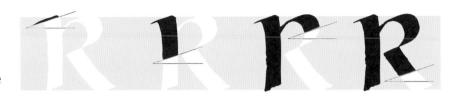

Body height

Body height is determined by the width of the nib. For Uncial, the x-height varies from between 3 and 5 pen nibs according to the desired result. The guidelines are drawn following that spacing. In the examples shown on pages 46 and 47, the x-height is 4 nibs wide.

We can see that certain letters are different heights, with an overshooting of the x-line (D, H, L) or an undershooting of the baseline (F, G, Q, Y), equal to about a nib width.

✒ Important: when you're drawing the nib-widths, don't put any pressure on the nib.

Pen angle

The slant angle is usually 20°.

20°

The diagram above represents the angle of the pen when drawing R. Whether the movement is vertical, curved, or oblique, the angle doesn't change.

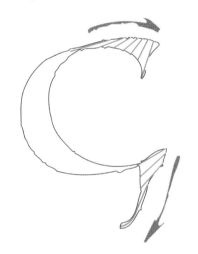

Special endings

Some endings in Uncial are unusual (C, E, G, J, K, S, V, W, X). We obtain this effect by pivoting the pen between the thumb and forefinger on one of its angles (right or left according to the direction of the line), while continuing to draw. This has the effect of modifying the 20° angle until

it is vertical. Here we have used the letter G as an example. The blue lines show the nib's angle.

Punctuation and ligatures

Punctuation as we know it today didn't exist in the time of Uncial. Below are punctuation marks created in the Uncial style, and a few ligatures, including the ampersand (&), constructed with the ligature of the letters E and T.

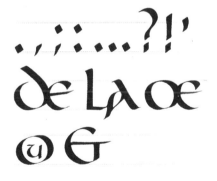

✒ *Throughout the book, these nib symbols mark important points to remember.*

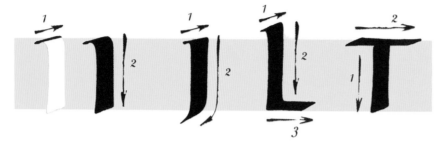

Begin with the straight letters: I, J, L, T. Don't forget about the pressure of the nib: attack/lighten/firm finish.

Combine the letters, keeping a regular intraspace. Check that the letters are properly straight and that they don't slant to the right or to the left.

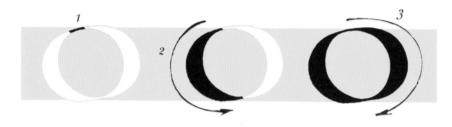

Then go on to the round letters: O, C, D, E, G, T, M, and S. Create combinations of the letters, and then mix straight letters and round ones.

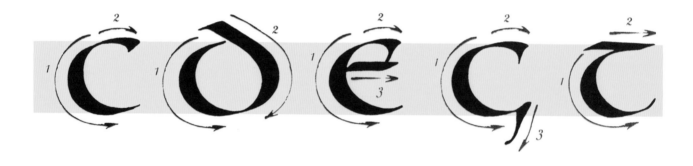

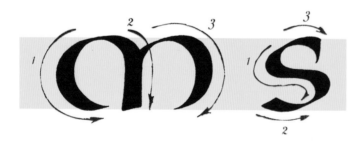

➥ Don't use any pressure on the curves or at the beginning of the obliques.

➥ Check the intraspaces by holding the paper at arm's length and blinking.

Forming the letters

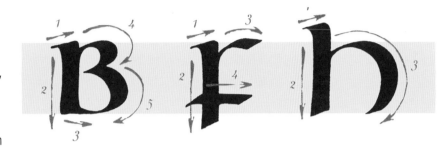

Next go on to B, F, H, P, Q, R, U, Y, and then A, K, N, V, W, X, and Z.

It's very important to pay attention to the position and the length of the lines in relation to the others.

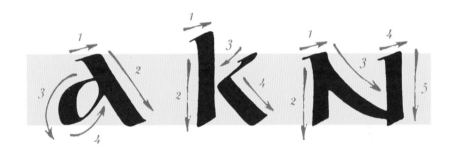

Once you have studied the structure of all the letters, write the following sentence, which contains all the letters of the alphabet: "The quick brown fox jumps over a lazy dog." Then practice by writing short texts that offer a lot of combinations.

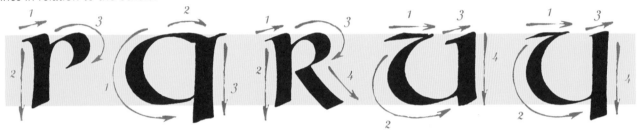

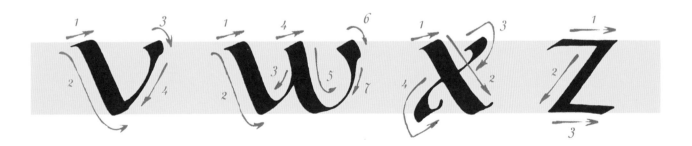

Numbers

The examples below don't correspond to a historic version, because at the time of Uncial script, Roman numerals were used. Instead, it's an interpretation, taking into account the spirit of the Uncial letters.

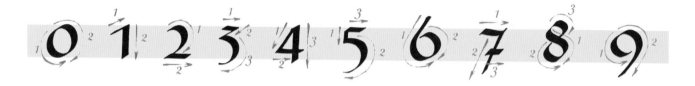

Project: A text

Look at the spatial outline, to the right. It uses a dropcap, and is composed in a block—all the lines are aligned to the left and to the right. Create a text using Uncial, following this format. One example is below.

Technical notes

Paper: white Conqueror
Tools: dropcap with an Automatic Pen #6, text with a C2 Speedball Pen
Medium: gouache
Size: 25.6" × 19.7" (65 × 50 cm)
X-height: 4 nib widths

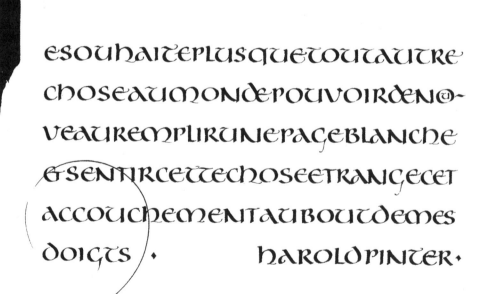

Project: A wine list

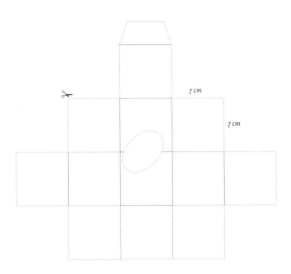

Technical notes

Paper: Ingres
Tools: dropcaps with a sable-hair brush, text with C1 and C3 Speedball Pens
Medium: gouache
Cube size: 2.75" × 2.75" × 2.75" (7 × 7 × 7 cm)
X-height: 4 nib widths

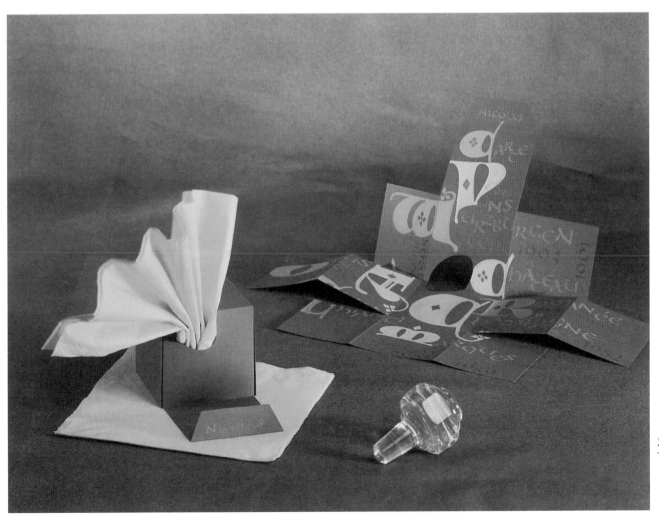

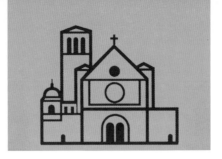

CAROLINGIAN

Following the expansion of the Roman empire and the diversification of Latin, the influence of the people called "barbarians" modified the Roman Cursive script; during the seventh century it became the base of numerous regional scripts, including Merovingian, Visgothic, Lombardi, Insular, and others. At the beginning of the eighth century, at the Corbie monastery in France, an effort to standardize the scripts appeared: this was the outlining of the first forms of Carolingian script. The formation of this script wasn't the result of a more or less spontaneous and random evolution, but instead was the result of a deliberate project, meant to serve the needs of the Carolingian revival. Charlemagne decreed its official use in 789.

Even though it was the result of work in several workshops, Carolingian was mainly established in the scriptorium of the monastery of Saint-Martin-de-Tours, under the direction of the monk Alcuin of York, and then by his successor Frédégise who completed it in the ninth century.

The Carolingian minuscule script is very legible because of its regularity; in addition, it includes a space between words. This lowercase alphabet was so successful, in both secular and religious worlds, that it remained almost unchanged for four centuries.

As time moved on and the thirteenth century approached, Carolingian minuscule gave uniformity to the different West European scripts that began to develop and succeed it.

Carolingian: About the script

Evolution of Carolingian script

Primitive Carolingian.

It's generally agreed that Carolingian script reached its purest form in the ninth century.

At the beginning of the tenth century, the forms became angular.

Late Carolingian: Foreseeing the Gothic era (broken forms, straightness).

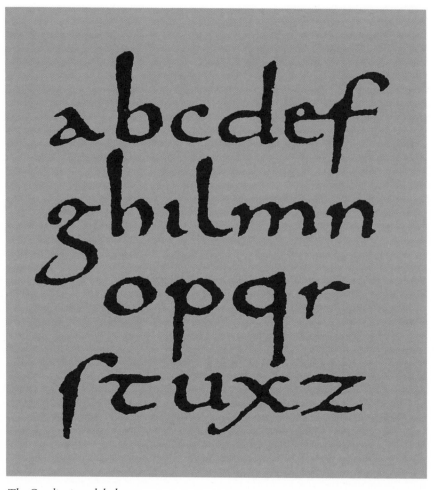

The Carolingian alphabet.

Carolingian is a minuscule script (and, in fact, is also called "Carolingian minuscule"). This means it has only lowercase letters. It is a reduced form with assertive ascenders and descenders. Even though it isn't a cursive script in the true sense of the meaning, its form—spread out on the baseline, and with some letters (m, n) being slightly italic—gives it a cursive aspect.

While it was rather spread out originally, during its evolution Carolingian script became tighter and straighter and its supple lines broke apart until it became Gothic script. Again, note that there are no capital letters in Carolingian. Instead, Uncial, Roman capitals, and Rustica were used with it.

Carolingian: Characteristics

Body height

The letters' body height is determined by the width of the nib. For Carolingian, the x-height is about 3 nibs. The guidelines are drawn following that spacing.

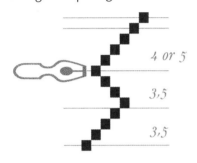

4 or 5

3,5

3,5

●✛ Important: when you are drawing the nib widths, don't put any pressure on the nib.

●✛ Because of the prominent ascenders and descenders, be sure to plan enough space between lines (called interspace) to avoid stroke crossings!

Pen angle

The angle is usually 30°.

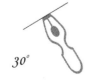

30°

Note that the characteristic apex of letters such as I, N, M, or U are formed in two movements:

These movements are what create the powerful look of the apex.

The apexes of the ascenders, which are also unusual, are formed in two movements as well:

In the alphabet shown on the opposite page, you may have noticed the special form of the S (1), which is different from the normal curvy S (2):

This is a historical form called a "long S." The second form appeared later and was only used at the end of a word.

Punctuation and ligatures

Punctuation as we know it today didn't exist in the time of Carolingian. Below are punctuation marks created in the Carolingian style, and a few ligatures, including the ampersand (&), constructed with the ligature of the letters E and T.

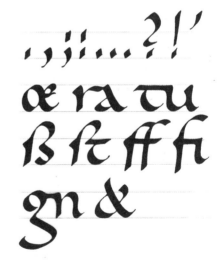

33

●✛ *Throughout the book, these nib symbols mark important points to remember.*

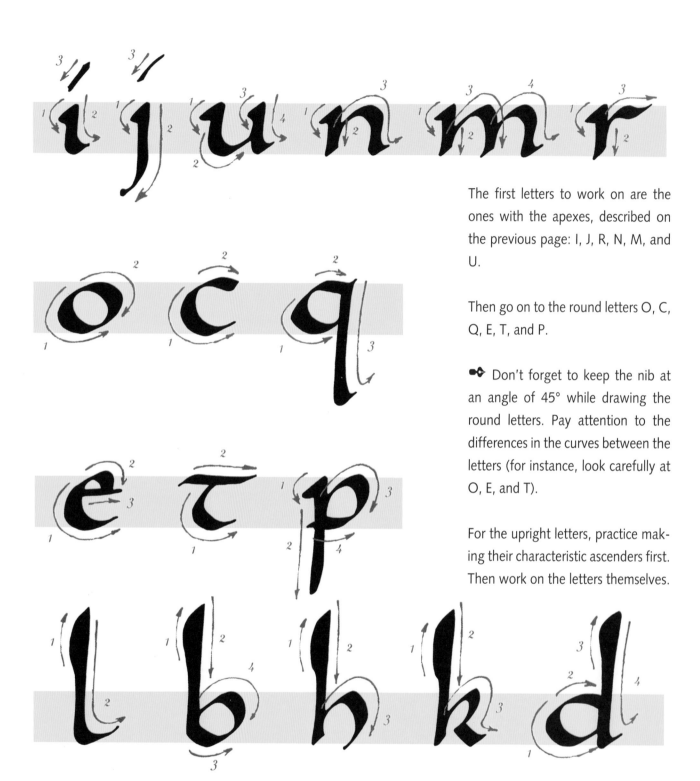

The first letters to work on are the ones with the apexes, described on the previous page: I, J, R, N, M, and U.

Then go on to the round letters O, C, Q, E, T, and P.

☛ Don't forget to keep the nib at an angle of 45° while drawing the round letters. Pay attention to the differences in the curves between the letters (for instance, look carefully at O, E, and T).

For the upright letters, practice making their characteristic ascenders first. Then work on the letters themselves.

Forming the letters

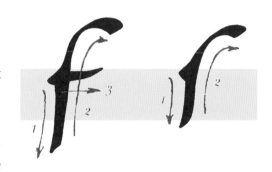

The F goes below the baseline, but the long S doesn't.

Next work on the letters V, W, X, and Y. Notice that the apex of these letters is a simple stroke, without the pressure that's applied for the letters like I, N, and U.

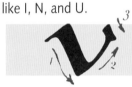

●✎ If it is important to follow the guidelines for the x-height of the letters—and as you learned, it is!—it's just as important to consistently follow the heights that correspond to the upstrokes and downstrokes. This gives your work visual consistency.

Throughout your learning process, don't ever hesitate to go back and work again separately on the specific parts of a letter you've been having problems with, for example, ascenders, starts of strokes, or the long S.

After the first exercises, instead of working on isolated letters, compose words and sentences to help you develope a good writing rhythm.

Finish with the other letters that have distinctive forms: A, G, short S, and Z.

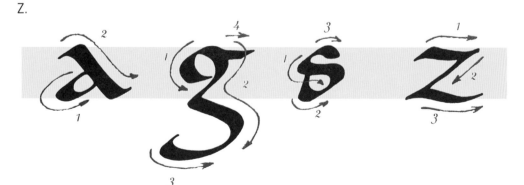

Numbers

The example below doesn't correspond to a historic version. Instead, it's an interpretation, taking into account the spirit of the Carolingian letters.

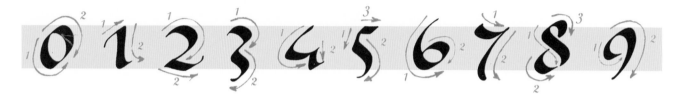

Project: A text

Look at the spatial outline, to the right, of a composition where the text is centered. The dropcap and the quotation marks were drawn separately, then redrawn onto the calligraphy. Create a text using Carolingian, following this format. One example is below.

Technical notes

Paper: white kraft
Tools: dropcap in felt-tip pen, text with a Michel's 1½ pen
Medium: gouache
Size: 11.7" × 16.5" (29.7 × 42 cm)
X-height: 3.5 nib widths

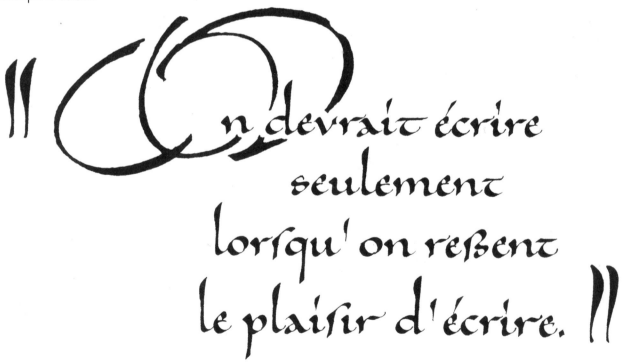

· IOURI · OLECHA ·

Project: Envelopes

Technical notes

Paper: various envelopes
Tools: diverse mediums and sizes
X-height: 3.5 nib widths

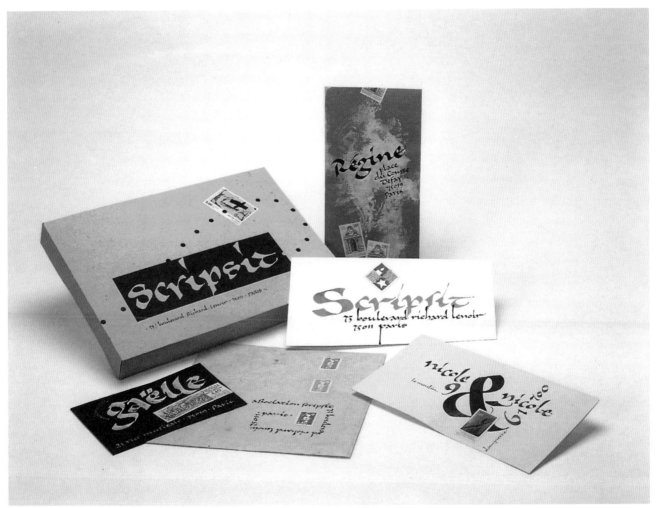

TEXTURA

In the tenth century a tendency to break the line of the letters appeared. Between the eleventh and thirteenth centuries Carolingian script transformed little by little into Gothic script, which is not exactly a new script, since it kept the same ductus. However, the letters became narrower, the curves were broken, and the black/white contrast is more highlighted. The increased need for books, due to an intellectual revival and the creation of universities, spread the art of writing to secular society.

There are different forms of Gothic script. Textura, the script of books, is very "calm" and controlled. Gutenberg used this for engraving the first printing characters in 1456, used for printing the Bible. This was the birth of Western printing.

Other forms of Gothic script included Gothic Cursive, which was widely used, especially for colloquial language, and was characterized by the ligature of the letters and by the many abbreviations it included. Rotunda, a rounder form of Textura, was mostly used in Italy and Spain. There was also Schwabacher, a script typical of the German Renaissance in the fifteenth century, which was used for engraving wood; and Fraktur, a script used by German chancelleries in the sixteenth century.

Textura: About the script

Evolution of Gothic script toward Textura script.

Primitive Gothic in the thirteenth century.

Primitive Gothic in the fourteenth century.

Textura in the mid-fifteenth century.

Xylographic (engraved on wood) Textura at the end of the fifteenth century.

Fifteenth-century Textura alphabet.

For practical (the bevel of the nib), cultural, economic, and social reasons, the roundness of Carolingian script evolved toward the straighter, vertical, and angular letters of Gothic script. Its more notable traits are the narrow vertical forms, the rhythm formed by the optical alternation of the black and white lines, and a rigorous, sometimes a bit stiff, appearance.

Mostly used in books, Textura is a script with great regularity. That gives it an almost uniform effect.

Textura: Characteristics

Body height

Textura letters' body height varies from 4.5 to 5.5 nib widths, depending on the desired result. The guidelines are drawn following that spacing. In the examples shown on pages 42 and 43, the x-height is 5.5 nib widths.

For the ascenders and descenders, plan on an overshooting distance equal to 1 or 2 nib widths.

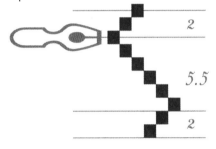

Pen angle

The angle is usually 45°.

When you write Textura calligraphy, the challenge of keeping to a certain angle is easier to overcome because it is essentially composed of straight lines—vertical, horizontal, or oblique—and the curves are almost nonexistent (at least in lowercase).

●❖ Each line that makes up the letter has an apex. It isn't always represented in the ductus, but even so, you need to be conscientious about drawing it. In the diagram here, it is indicated in blue.

The apex prepares you for the stroke and ensures that the nib is in proper contact with the paper and that the medium is flowing correctly.

The equality of the lines

In the below diagram, notice the directions of the lines at the head and the foot of the letters. This variation in the letters is what will bring your Textura to life. Your challenge lies in counterbalancing the strokes so that the letter appears very straight.

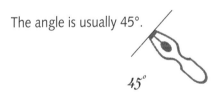

●❖ When the actual structure of a lowercase letter is rather simple, put your effort into the modulation of the lines' width, the equilibrium of the letters, the rhythm of the intraspaces, and the counters.

Punctuation and ligatures

Punctuation as we know it today didn't exist in the time of Gothic Textura. Below are punctuation marks created in the Textura style, and a few ligatures, including the ampersand (&), constructed with the ligature of the letters E and T.

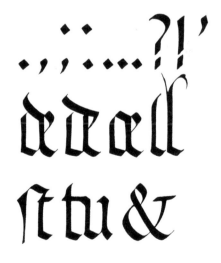

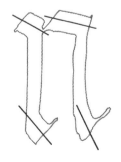

●❖ *Throughout the book, these nib symbols mark important points to remember.*

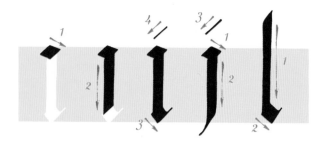

Begin with the letters I, J, L, R, N, M, V, W, U, Y, and P. In this type of script, the pressure put on the nib is very important because it gives life to the line and gives a warmer, less rigid aspect to the letter as a whole.

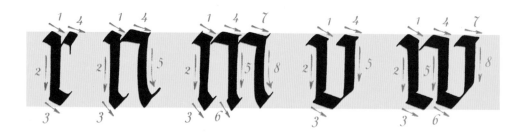

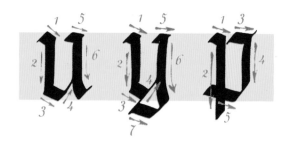

Combine the letters, carefully keeping a consistent intraspace. For example, write the word "minimum." Check that all the letters are properly balanced and that they don't slant to the left or to the right.

●✛ To "sit" the letters down, increase your pressure on the foot.

●✛ Check to make sure that the nib remains at a 45° angle.

●✛ Pay attention to correctly forming the different lengths and directions on the lines at the base. These determine the legibility and the correct balance of the letter.

●✛ Pay attention to the letters such as R, T, and X, which have a tendency to create white spaces that are too big. In that situation, don't hesitate to pull the letters closer to obtain a good intraspace.

Forming the letters

Move on to the letters O, Q, B, and H, and then C, E, and A. Make combinations of letters in these two groups, and then mix the first group's letters with the second.

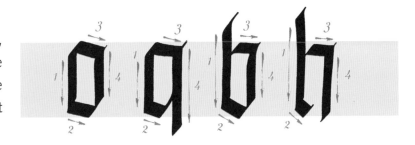

➤ The third line in the letter A is done with the right angle of the nib.

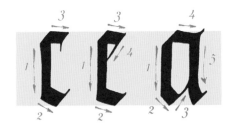

Now study the letters T, F, K, D, and G, and finally X, S, and Z.

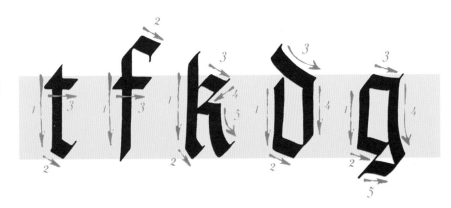

Once you have studied the structure of all the letters, write the following sentence, which contains all the letters of the alphabet: "The quick brown fox jumps over a lazy dog." Then practice by writing short texts that offer a lot of combinations.

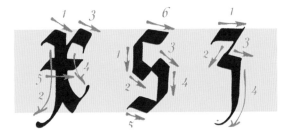

Below: the ductus of the Textura capital N is shown stroke by stroke.

Observe the position of the lines drawn in relation to the ones waiting to be done.

Form the rest of the letters on this page, looking at the ductus in the same step-by-step way, and focusing on the lines' relative positions.

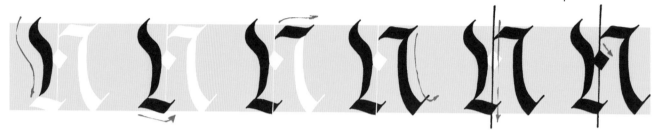

☛ Do the vertical line with the nib in a vertical position.

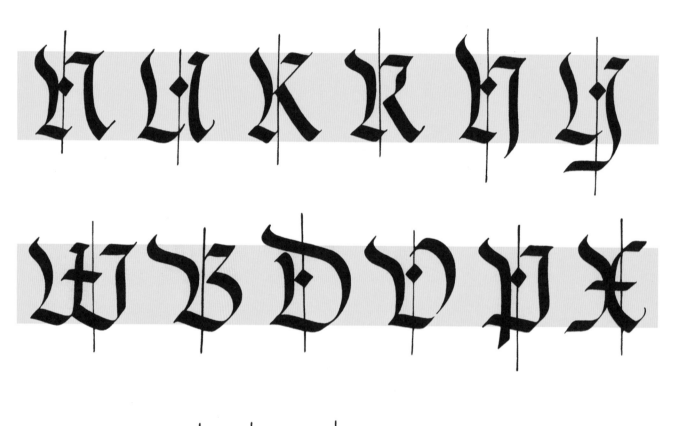

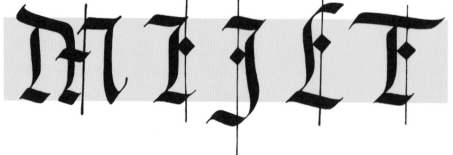

Here the capital C is shown stroke by stroke. Start with this letter.

Do the vertical line and the small diamond last.

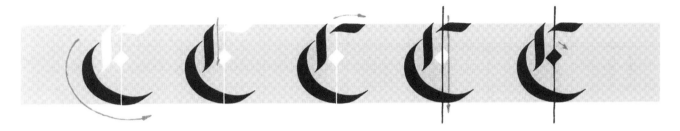

Go on to letters E, G, O, and and Q.

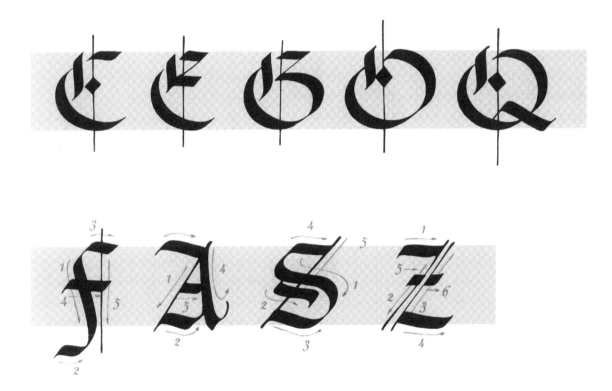

The ductus of the letters F, A, S, and Z is unusual. Study these letters separately from the others.

Numbers

The example below is a partial inter-
pretation, following the style of the
letters.

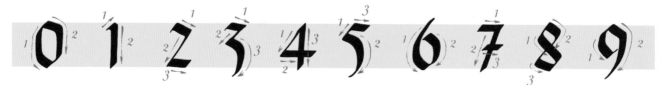

Project: A text

When you feel that you have mas-
tered the structure of each letter, the
pressure on the nib, and the quali-
ty of the lines and intraspaces, find
some phrases or bits of text that you
like, and calligraph them.

This is an example of a composition
aligned to the right, which means
that you first have to calculate the
length of each line.

Technical notes

Paper: white Conqueror
Tools: dropcap with Automatic Pen
#4, text with Speedball pen C2
Medium: gouache
Size: 12.6" × 17.7" (32 × 45 cm)
X-height: 5.5 nib widths

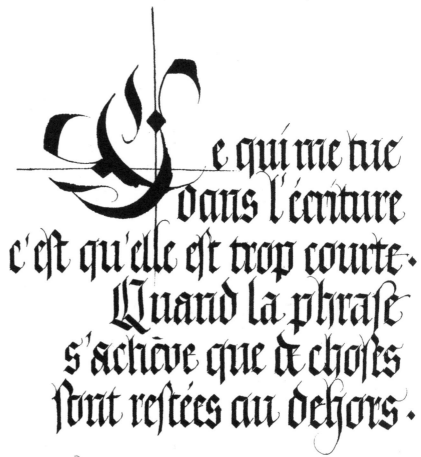

Ce qui me tue
dans l'écriture
c'est qu'elle est trop courte.
Quand la phrase
s'achève que de choses
sont restées au dehors.

j·m·g·le·Clézio

Project: A calendar

Technical notes

Paper: Johannot
Tools: Speedball pen, Automatic pen
Medium: ink
Size: 21.7" × 28.3" (55 × 72 cm)
X-height: 5.5 nib widths

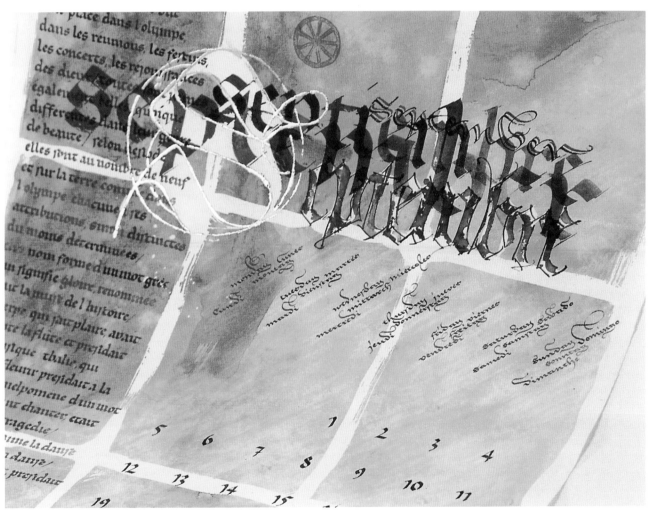

CHANCERY

From Antiqua, a calm "book-like" script, came a cursive form: Humanist Cursive. At first it was used for works that didn't need to be particularly neat (like civil, religious, judicial, and administrative records). The speed of writing the script led to a slight incline, ligatures between letters, their narrowness, and a new shape borrowed from Gothic Cursive, especially noticeable in the letters a, g, and f.

From Humanist Cursive, an elegant form was developed in the Pope's chancellery. It began to spread, first in Italy and then through other European countries (including France, England, Holland, and Spain) where it enjoyed great success. This is Chancery.

Chancery: About the script

Evolution of Humanist Cursive to engraved Chancery.

1477, Italy.

Pro sedandis certis gtrouer
Venctiazo · 7 Abbati Sti G
psonis tanq̃ ꝯmuⁱⁱs 7 amic

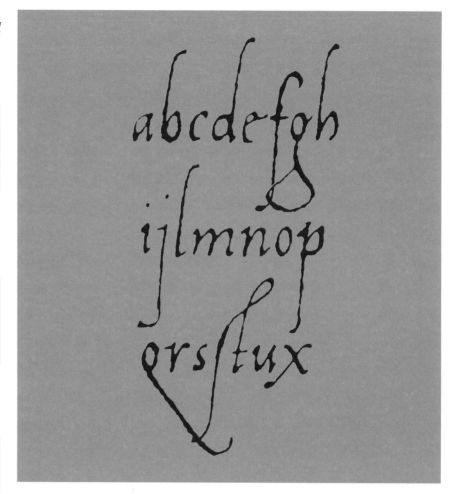

Chancery alphabet.

Around 1500, Italy.

Et quocũqz deũs circũ caput
Ergo nre ſmu baccho dicemus
Carminibus prijs lancesqz et l

Letter written by Pope Alexander VI, 1501, Italy.

ılectum filium nrm · Geor · ti
francie̅ deputauimus · prou
solatione pampliis proſpı

Tagliente, 1524, Italy. Engraving on wood.

longe̅ large̅ traiizzate ꝯnon traiizute ET
to ſcritto quꝗ ta'uariacione' de lettera'
pareraj seaundo li noſtri precetti et

Chancery is an oblique script. It is characterized by the horizontal ends of the ascenders, and by its long, narrow forms: there is little roundness and few broken lines in Chancery. Although it comes directly from the rapid Humanist Cursive lines, Chancery, the set version of this cursive, is a calm script. This doesn't stop you from finding a lot of freedom when using it, especially with the multiple versions of the capitals.

Chancery: Characteristics

Body height

The letters' body height is determined by the width of the nib. For Chancery the x-height is 5 nib widths. The guidelines are drawn following that spacing. The ascenders are 4 nib widths and the descenders are 3 nib widths.

With Chancery script, while it is important to draw the guidelines corresponding to the x-height, the ascenders, and the descenders, you should also mark your page with lines matching the slant angle, which is 9°. This will give you a visual reference and help you to maintain a consistent slant.

Pen angle

The angle is 45°.

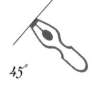

The tightness of the curves

In letters such as A, D, G, Q, U, and Y, it's important to go up to the top before drawing the last line; and for B, H, M, N, P, and R, it's important to draw the third line up from the bottom of the letter. This is to correctly associate the two lines.

The essential principle of the forms in Chancery is found in the tension of the curves. We can summarize it like this:

These four points are present in a lot of the letters and form their skeleton. Of course, not all the lines you draw will pass by these four points (for example, note the top left point above in the letter A), but the curve will tend toward this point. In that way we obtain a "tight" line, which helps to keep the letter from becoming "soft." But be careful not to break the curves.

As you begin working with Chancery, you can mark the four dots with a pencil, and practice using them as reference points.

☛ To create a line with energy, don't forget to apply pressure on the nib at the beginning and at the end of the line in straight letters.

Punctuation and ligatures

Punctuation as we know it today didn't exist in the time of Chancery. Below are punctuation marks created in the Chancery style, and a few ligatures, including the ampersand (&), constructed with the ligature of the letters E and T.

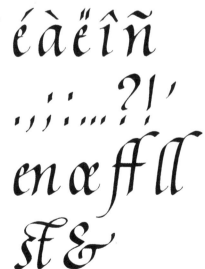

51

☛ *Throughout the book, these nib symbols mark important points to remember.*

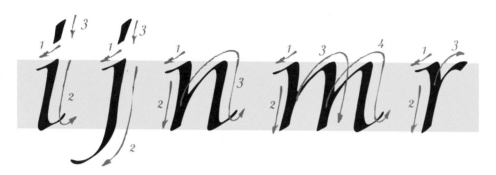

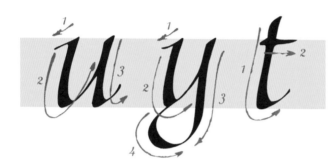

Start by working on the letters I, J, N, M, and R, and then U, Y, and T. Continue with the "round letters" O, C, and E.

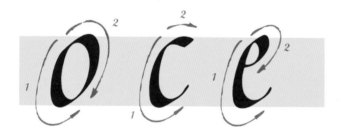

When you have practiced these letters, compose lines of "*no*" that are as consistent as possible in terms of their intraspaces. This will help develop your eye for adjusting the spaces.

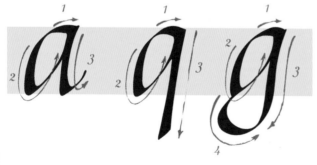

For the letters A, G, and O, note the difference in the slant in relation to the preceding group: the letters like A and Q have an ascender that stabilizes them, which isn't the case for O or C. Therefore, we straighten the A and Q slightly to balance them.

Forming the letters

The main difficulty with ascender letters is the flexibility that the ascenders need to have: far from being rigid, they have a slightly curved aspect all along them (a sinuous movement in F).

The letters B and P have an identical belly, while D copies the belly of A and the ascender of L.

You should visualize and understand the difference in the movements of the ascender in B (slightly sinuous) and in D (slightly convex). We find this same difference in the letters H and K in relation to L.

When beginning the oblique letters V, W, and X, make sure that their slant is optically identical to that of the other letters, which are at 9°.

Finish by working on the letters S and Z (a median Z—used in the middle of words—and a terminal Z with a broader finish). Don't put too much movement into the vertical core of S because the sinuousness that characterizes it is created by adding the two opposing extremities.

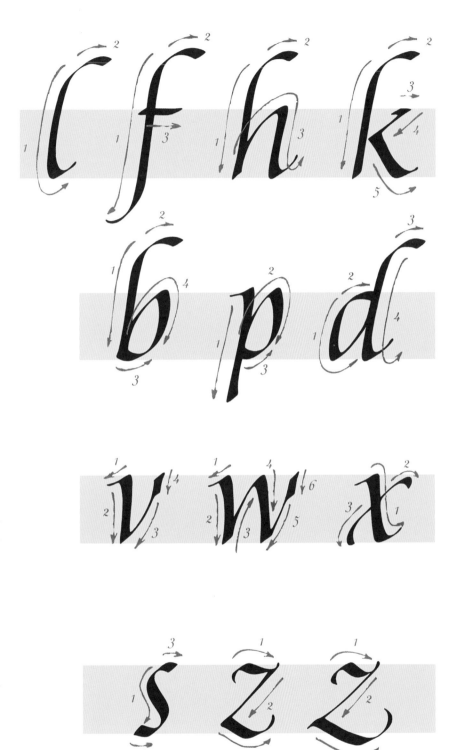

A M N H

I P T R K

F J U

B D L

No matter what stage of learning Chancery you may be at, keep these basic facts in mind:

• A consistent slant means first drawing the 9° slant guidelines with a pencil.

• The nib's angle of 45° should remain the same during the entire process.

• Any changes in direction in a letter should be done abruptly, like a swerve taken at the last minute, to avoid creating an excessive roundness. However, you shouldn't break the lines of the curves.

54

C O G G Q X

V W W N

E S Z

Numbers

The example below is based on the
the spirit of the Chancery letters.

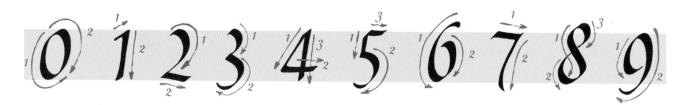

Project: A text

Here is an example of a text aligned
on the left. Create a text using Chan-
cery, following this format.

Technical notes

Paper: Ingres d'Arches
Tools: dropcap with a Speedball pen
C0, text with a #2 Mitchel's pen
Medium: gouache
Size: 15.75" × 19.7" (40 × 50 cm)
X-height: 5 nib widths

Project: Letterhead

Technical notes

Paper: Ingres
Tools: Mitchell and Brause pens
Medium: gouache
Size: 8.3" × 11.7" (21 × 29.7 cm)
X-height: 5 nib widths

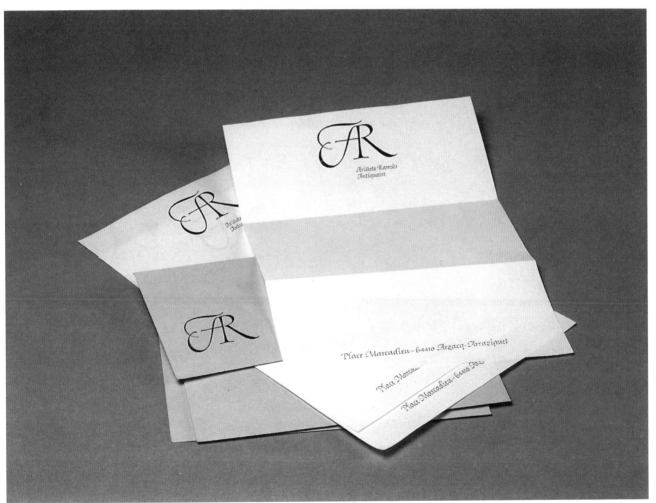

Baroque art

ENGLISH

Following Italian Chancery script, and influenced by the prevalence of a more and more pointed nib that allowed for strong contrasts between downstrokes and upstrokes, several different bastarda scripts arose, one after another. The final form of these is English script.

It became a script that dominated all of Europe. Its popularity expanded during the British empire due to its wide commercial use, the speed of writing it, and its legibility. The invention of metal nib pens, the first durable "ready to use" writing tool, also helped firmly establish English script.

The cursive handwriting that's taught in elementary schools today—those schools that still teach handwriting at all, that is!—is based on English script.

English: About the script

Evolution of the script to English.

The Flemish School, Carpentier, 1620, Haarlem.

Bastarda, Roland, 1758, Paris.

Coulée, Bourgoin, 1810, Paris.

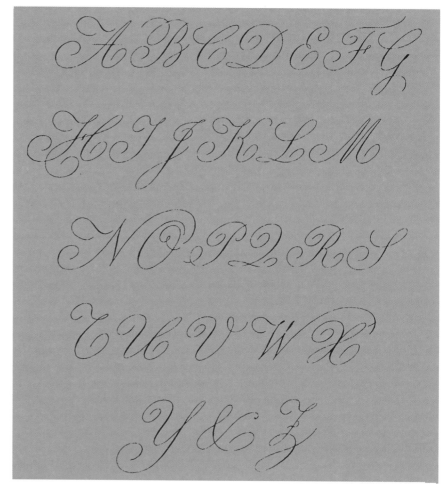

Facsimile of Young Renier English capitals, ca. 1847.

English, Champion, 1739, London.

English script is very slanted, ligatured (joined), and very regular in the rhythm of its lowercase letters. Structured on a series of ovals, it is supple without any breaks. Its spectacular arabesques are created, in its lowercase letters, from the extension of the ascenders and descenders, or at the end of a word. There two types of capitals: those intended to be integrated into a word, and those placed at the beginning of a text, which are richly ornate.

60

◆➤ *Throughout the book, these nib symbols mark important points to remember.*

English: Characteristics

English script is drawn with a pointed nib which can be straight or oblique. The letters slant at 55°. Just as you did with Chancery script, you should mark your page with guidelines matching the slant angle. This will give you a visual reference and help you to maintain a consistent slant.

➥ If you are using a straight nib you should tilt the page at the slant; if you are using an oblique pen nib holder, the page stays straight.

Body height

There is no precise letter height, but instead, a ratio of three between the lowercase and uppercase: capital letters are three times bigger. To start, draw guidelines at ⅜" (1 cm) for the lowercase x-height and at 1³⁄₁₆" (3 cm) for the capitals. The height of the ascenders and descenders will be at 1" (2.5 cm), except for d, p, and q, which will be at 1³⁄₁₆" (2 cm), and t, which will be at ⁹⁄₁₆" (1.5 cm).

Downstrokes and upstrokes

Obtain the downstrokes and the upstrokes by the pressure and release applied to the nib: a thicker downstroke and a thinner upstroke, like this:

It's a good idea to practice this exercise before attacking the alphabet.

When you pass from the downstroke to the upstroke, such as in the numeral 1 for example, the movement should be tight, which will make the oval very narrow. To obtain a good rhythm in the row of letters, you should avoid roundness: look at the word "écriture" at right.

Puncuation and ligatures

Below are punctuation marks; a few ligatures, including the ampersand (&), constructed with the ligature of the letters E and T; and some variant forms of letters.

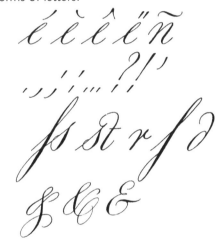

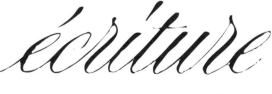

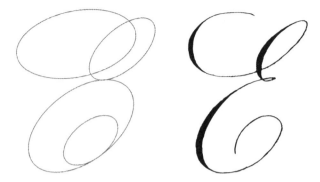

Working on the capital is essential. It will let you familiarize yourself with a pointed nib and with the arabesques that are particular to English script, and will help you to acquire flexibility in your movements.

◆ The axis of the downstroke corresponds to the axis of the oval: 55°.

The base form is the oval. At the beginning, it's better to draw, in pencil, the ovals that compose the letters, because that will help you to understand their structure and will give you a guide to help you maintain their proportions.

Then create the lines with the pen following the ductus indicated for each.

◆ All the strokes end following an elliptical form.

Work on groups of letters together. Each group here corresponds to similar structures.

To draw the downstroke (for example, the first line of B), apply firm pressure on the nib only when it is parallel to the inclination axis (55°).

D is drawn in a single movement.

M and N should be narrow.

Forming the letters

Q is drawn in two movements.

With the letters C, G, E, L, and S, the first downstroke isn't as thick as the second, it is half as wide, just like the second line of Z.

For the letters to be read correctly, you should focus on the letter's particular structure, and not the ornamentation of the arabesques attached to it. See the example at left.

For the downstroke of certain letters, as in the examples at left, set the nib parallel to the guideline.

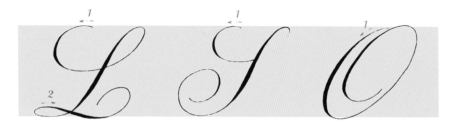

❧ It is permissable to cross two up-strokes or a downstroke and an up-stroke, but not two downstrokes.

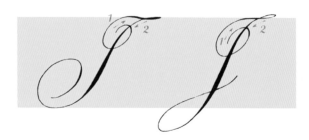

❧ As a general rule, avoid equality or "matching" of the different parts of a letter, and in particular between the sizes of the ovals that compose it.

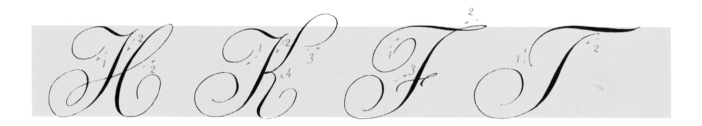

●✧ The form of the lowercase letters' base is a narrow oval. Avoid making them round.

Note the slight wave in the down-stroke of G, J, and Y.

●✧ The ligatures linking the letters together are done on the level of the optical center.

Create dots and punctuation marks with the same care you use for the letters.

The loops of R and S can overshoot the x-height.

Numbers

The numbers follow the style of the letters.

Project: A text

Here is an example of a text with asymmetric composition. It's an exercise in the balance between the masses (text and white space).

Here is an example of a text with asymmetric composition. It is a study in the correct balance between the text and white space. Create a text using English script, following this format.

L'écriture a ceci de mystérieux qu'elle parle.

Paul Claudel

Project: A greeting card

Technical notes

Paper: Ingres MBM
Tools: Copperplate pen
Medium: watercolor
Size: 8.3" × 11.7" (21 × 29.7 cm)

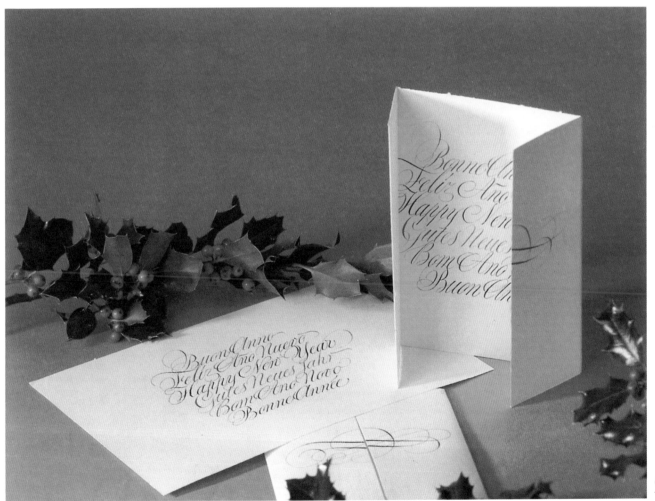

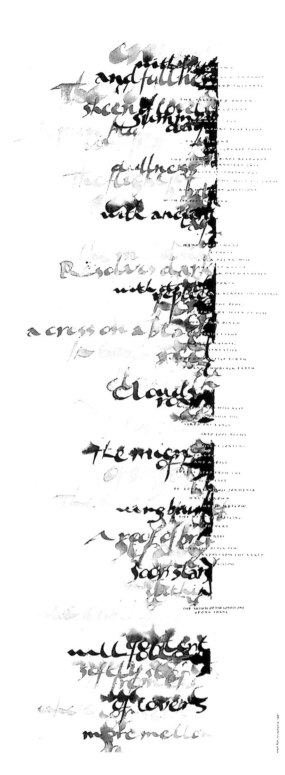

▲ *Bernard Arin, France. Greeting card—alphabet primer ("angled cryptography"). 21 × 10 cm. Felt-tip brush on 220 g rag paper.*

► *Franck Jalleau, France. 57 × 46 cm. Gestural, drawing pen on printed type background, Arches paper.*

◄ *Anna Ronchi, Italy. "The Autumn of the Lonely One," text by Georg Trakl. 38 × 95 cm. Automatic pen and gouache.*

Vincent Geneslay, France. "I sing . . . ," text by Jean Giono. 60 × 20 cm. Mitchell pen, walnut stain on white kraft paper.

▼

CONTEMPORARY WORKS

In these pages you'll discover works by modern calligraphers from around the world, which will allow you to widen your perspective on the many aspects of calligraphy, from gestural style to personal interpretation.

These particular works—most of them published here for the first time—have been chosen to show the wide range of possibilities and interpretations, both formal and informal, that calligraphers can apply to the alphabet.

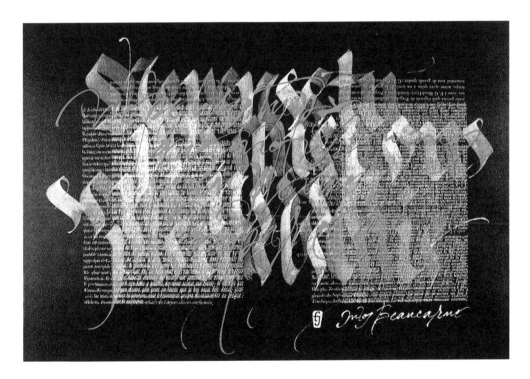

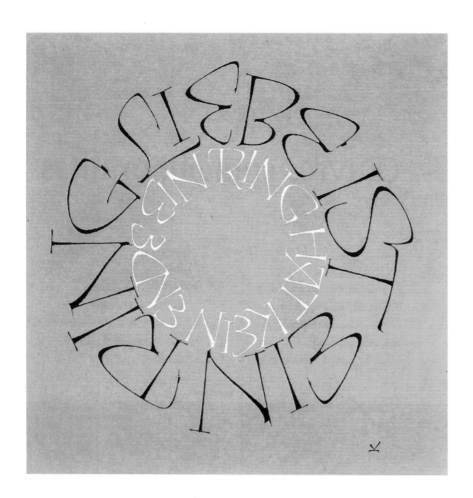

◀ Hermann Kilian,
Germany.
"Love is a ring." 28 ×
28 cm.

▶ *André Brenk,
France.*

▶ *Laurent Rébéna,
France.
Text by Jean Giano.
28 × 44 cm. Cop-
perplate pen, black
gouache on Arches
paper.*

*On ne peut pas vivre dans un Monde
où l'on croit que l'élégance Exquise
du Plumage de la Pintade est inutile.*

Jean Giono

GOTT hat dem Menschen
die Zeit gegeben,
von Eile hat er
nichts gesagt.

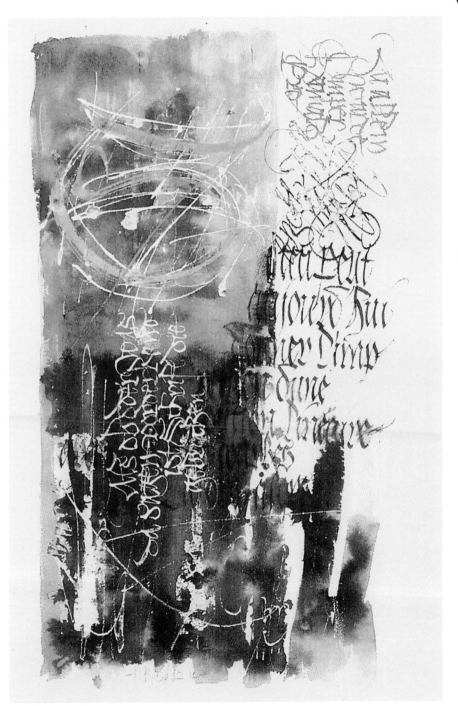

▲ Hermann Zapf,
Germany.

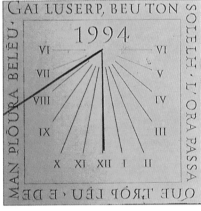

GAI LUSERP, BEU TON
1994
VI VI
VII V
VIII IV
IX III
X XI XII I II

▲ Rodolphe Giu-
glardo, France.
Vertical sundial. 52
× 52 cm. Capitals en-
graved on limestone
from Saint-Hubert.
Colors: oxides and
eggwhite. "Gay liz-
ard, drink your sun,
time passes only too
quickly and tomor-
row it might rain."

71

▼ *Michel d'Anasta-*
sio, France.
Alphabet primer. 24
× 32 cm. Drawing
pen, white India ink
on black Canson
paper.

▼ *Guy Mocquet,*
France.
Rotunda text. 70 ×
50 cm. Metal nib
quill, ink.

◄ Giovanni di Fraccio, Italy. Alphabet primer. 30 × 40 cm. Ruling pen and Speedball pen.

▶ Karlgeorg Hoefer, Germany. Chinese proverb. 21 × 29.7 cm. Brush and India ink.

François Boltana, France. Alphabet primer. 65 × 50 cm. Brush, gouache on black Canson paper.
▼

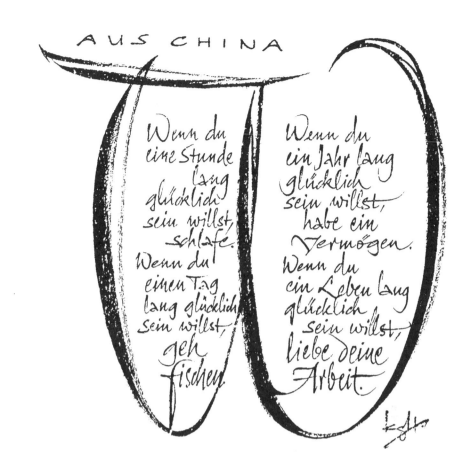

AUS CHINA

Wenn du eine Stunde lang glücklich sein willst, schlafe. Wenn du einen Tag lang glücklich sein willst, geh fischen.

Wenn du ein Jahr lang glücklich sein willst, habe ein Vermögen. Wenn du ein Leben lang glücklich sein willst, liebe deine Arbeit.

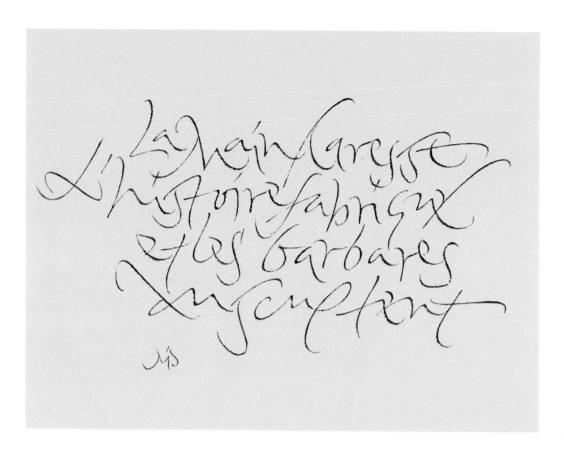

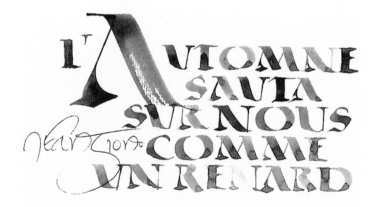

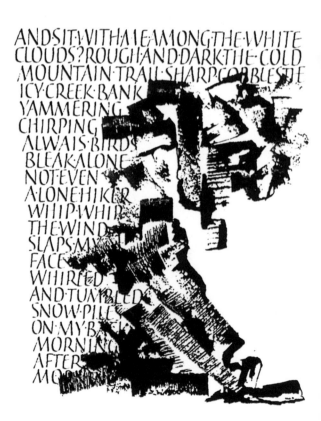

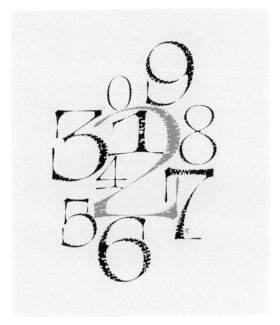

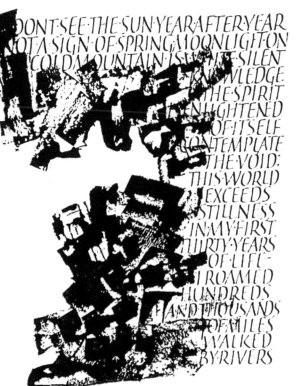

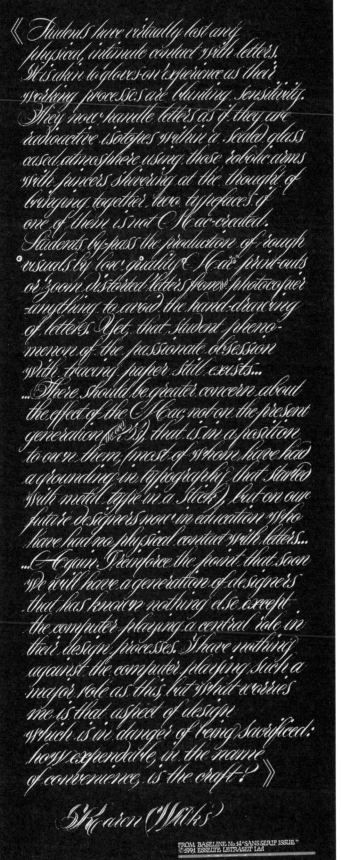

« Students have virtually lost any physical, intimate contact with letters. It is akin to gloves-on experience as their working processes are blunting sensitivity. They now handle letters as if they are radioactive isotopes within a sealed glass cased atmosphere using those robotic arms with pincers shivering at the thought of bringing together two typefaces if one of them is not Mac-created. Students by-pass the production of rough visuals by low-quality Mac print-outs or zoom distorted letters from the photocopier -anything to avoid the hand-drawing of letters. Yet, that student pheno-menon of the passionate obsession with tracing paper still exists... ...There should be greater concern about the effect of the Mac, not on the present generation (like us), that is in a position to own them, (most of whom have had a grounding in typography that started with metal type in a stick) but on our future designers now in education who have had no physical contact with letters... ...Again I reinforce the point that soon we will have a generation of designers that has known nothing else except the computer playing a central role in their design processes. I have nothing against the computer playing such a major role as this, but what worries me is that aspect of design which is in danger of being sacrificed: how expendable, in the name of convenience, is the craft? »

Karen Wilks

Laurent Pflughaupt,
France.
Mixed techniques.

Jenny Groat, USA.

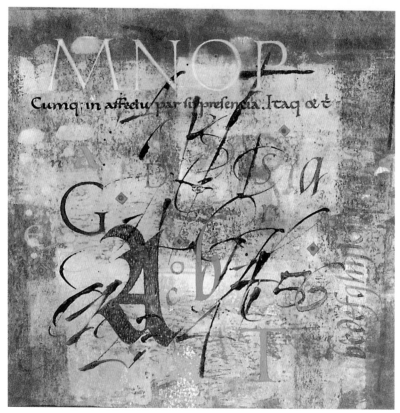

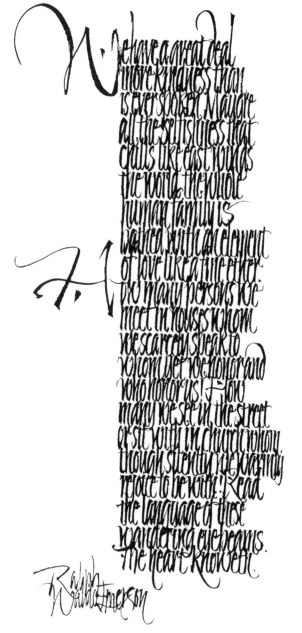

Les oiseaux
sur la page aux marges infinies
l'espace qu'ils mesurent n'est plus qu'incantation.
Ils sont, comme dans le mètre, quantités
syllabiques. Et procédant, comme le mot, de lointaine
ascendance, ils perdent, comme le mot,
leur sens à la limite de la félicité.

Laurence Bedoin-
Collard, France.
49.5 × 33 cm. Brause
pen, watercolor on
Ingres d'Arches paper.

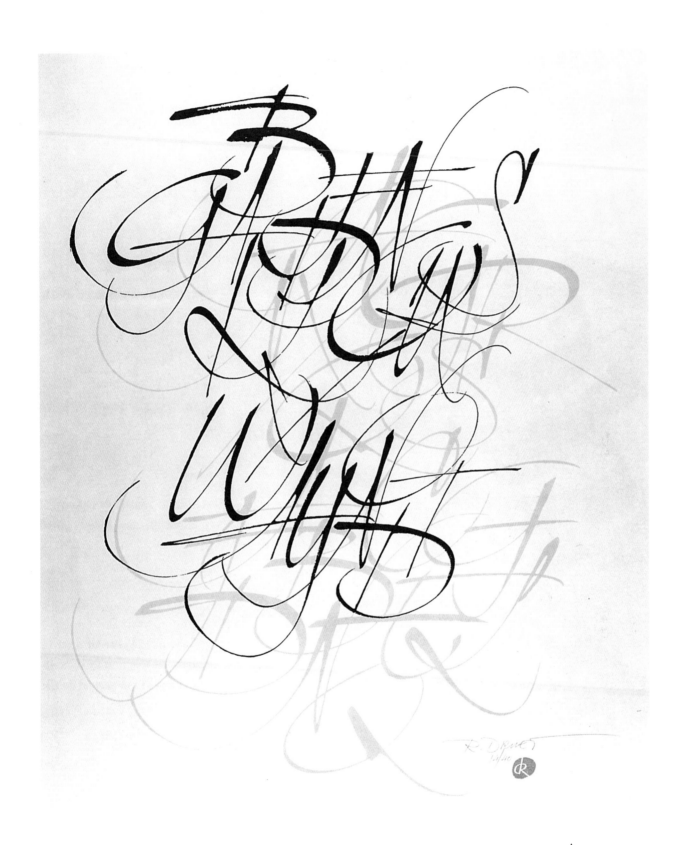

Roger Druet, France.
"Letter Game." 58 ×
76 cm. Speedball pen,
India ink.

Kitty Sabatier,
France.
Alphabet primer. 50
× 65 cm. Quill and
Automatic pen, ink.
▼

GLOSSARY

Apex: an element at the top of a letter having the form of a triangle or a widened bulge

Ascender: the part of the letter above the x-line

Belly: the round part of a letter

Body height: height of a lowercase letter including ascenders and descenders. (The x-height does not include ascenders and descenders.)

Counter: the space inside a letter. For example, the center area of the letter O.

Descender: the part of the letter below the baseline

Downstroke: thick line; its maximum thickness is the width of the nib

Ductus: the prescribed number, order, and direction of each stroke. These combine in creating a letter.

Guideline: horizontal lines, ruled on a sheet of paper, that mark the height of a letter and its constituent parts. In this book the guidelines include the baseline and the x-line (also called "waist line"). From bottom to top, four of the most common lines included in a guideline are the baseline, the x-line, the ascender line, and the cap line.

Interline spacing: space between the lines

Intraspace: space between the letters

Ligature: a character (for example, æ) consisting of two or more letters joined together

Nib width: the width of a line, which varies according to the size of the nib, and which determines the x-height

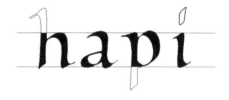

Serif: an ornamental finish of a letter's stroke

Upstroke: thin line, obtained by drawing a line parallel to the nib's flat side

X-height: height of a lowercase letter that has neither ascenders nor descenders. (The body height includes ascenders and descenders.)

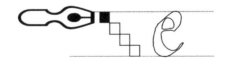

BIBLIOGRAPHY

Atkins, Kathryn. *Master of Italic Letters*. New York: David R. Godine, 1988.

Center for Typographical Research and Study. *De plomb, d'encre et de lumière*. Paris: Imprimerie Nationale, 1982.

Druet, Roger, and Grégoire Herman. *La Civilisation de l'écriture*. Paris: Fayard/Dessain and Tolra, 1976.

Gürtler, André. *Die Entwicklung der lateinischen Schrift*. Zurich: BSB, Bildungsverband Schweizerischer Buchdrucker, 1969.

Higounet, Charles. *L'écriture*. Paris: PUF, 1964, 2003.

Mallon, Jean. *De l'écriture*. Paris: Editions du CNRS, 1982.

Médiavilla, Claude. *Calligraphie*. Paris: Imprimerie Nationale, 1993.

Meyer, Hans. *Le Développement de l'écriture*. Zurich: Graphis Press, 1959.

Véronique Sabard, Vincent Geneslay, and **Laurent Rébéna** are calligraphers and graphic designers. They attended the Scriptorium of Toulouse, a center of study for typography and calligraphy, and are the founders of the Scripsit Association, an organization promoting calligraphy. www.scripsit.fr